Drawcademy

CARTOON DRAWING

FOR THE ABSOLUTE BEGINNER!

Turn Your Stick-Man into a 3D Toon!

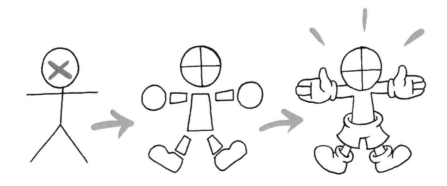

2nd Ed.

Drawcademy

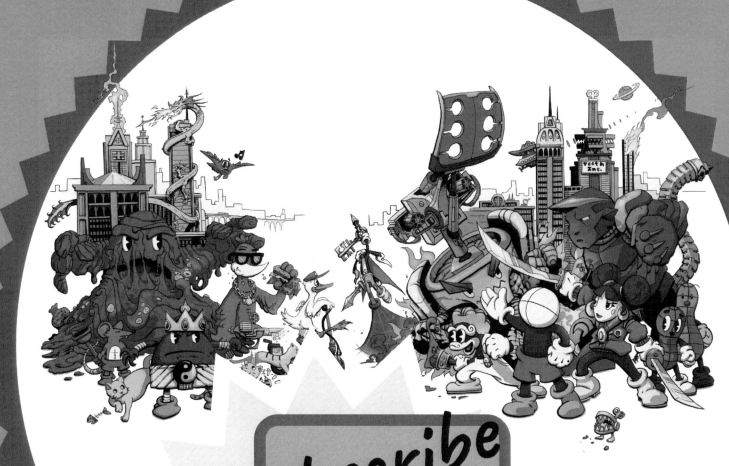

Subscribe

1 Month Free Trial

LEARN TO DRAW AT HOME!

WAIT!
FIRST, CLAIM YOUR MATCHING VIDEO COURSE!

If viewing digitally, click Tommy Toon
Or
Type in the URL:

https://www.drawcademy.com/p/cartoon-drawing-for-the-absolute-beginner

Inside this book you will find drawing lessons that are best used while accompanying my free video course. Enroll at no cost in my online illustration school, Drawcademy!

I'll see you in the course!
-Kevin Gardin

KEVIN GARDIN

B.A ILLUSTRATION WITH HONOURS
***BEST-SELLING* INSTRUCTOR**
@KEVINGARDIN

Kevin Gardin was born in Windsor, Ontario, Canada. He currently resides there after completing his Bachelor of Illustration at Sheridan College in Oakville, Ontario.

He has worked in a game studio as a concept artist and now is the owner of Kevin Gardin Illustrations and Gardin Painting. He provides services locally and online for both artwork creation and residential interior painting. Safe to say he's at home in the paint and brush department.

He began drawing at the age of 3 and has never stopped, always trying to make the next one better than the last. His greatest hope is that he can help you onto the right track!

These courses are his lessons on the most sought-after techniques an artist can come across. They are all designed to improve anyone at a quicker rate and at a fraction of the cost when compared to most post-secondary educations. And the best part is it's all in the comfort of your own home!

MITCHELL BOUCHARD

B.S, FILM & MEDIA ARTS
HOST @REDCAPELEARNING

Mitch is a Canadian filmmaker from Harrow Ontario, Canada. In 2016 he graduated from Dakota State University with a B.S, in Computer Graphics specializing in Film and Cinematic Arts.

Mitch operates as the Chairman of Red Cape Studios, Inc. where he continues his passion for filmmaking. He is also the Host of Red Cape Learning and Produces / Directs content for Red Cape Films. He has reached over 50,000+ Students on Udemy and Produced more than 3X Best-Selling Courses.

Mitch is currently working as a Graduate Assistant and is an MFA Candidate at the University of Windsor. Winning several awards at Dakota State University such as "1st Place BeadleMania", "Winner College 10th Anniversary Dordt Film Festival" as well as "Outstanding Artist Award College of Arts and Sciences". Mitch has been Featured on CBC's "Windsors Shorts" Tv Show and was also the Producer/Director for TEDX Windsor, featuring speakers from across the Country.

RED CAPE FILMS

EXCLUSIVE
PARTNERSHIP

Red Cape Films produces our content.

WWW.REDCAPEFILMS.CA

JOIN THE EXCLUSIVE

CREATORS FORUM

ON FACEBOOK!

Get Help With Your Art!
Network!
Enter Contests!

To get access, enter the membership password:

ACADEMY

www.facebook.com/groups/
exclusivecreatorsforum

Drawcademy

Tips for learning from home

CREATE A NOTEBOOK

A notebook will help you immensely with organizing your thoughts and keeping track of your art progress. You can use it to write down things you need to improve on or to scribble down small ideas for later use. Ultimately it is to improve the speed at which you learn.

SET A SCHEDULE

Set a time that you start practicing each day, even if it's for 20 minutes. It will help you stay organized and calm in days where things might be hectic.

Your time is precious and limited so use it wisely!

SET UP A WORK ZONE

Set up a comfortable, well-lit area and designate it for work.

Avoid working from the couch or bed - it's bad posture and might make you sleepy and distracted!

ASK QUESTIONS

Make sure to join the Creators Forum Facebook group. It is a positive space where other students like yourself can post their work and ask for critiques! Getting other people's perspectives is invaluable.

ASSEMBLE A PORTFOLIO

A simple way to make a portfolio is by taping two bristol boards together along the bottom and 2 sides with an opening at the top. You can use your portfolio to easily store all of the artwork you create in order to keep it together in one place.

PRACTICE AND BE PATIENT

Be kind towards yourself and realize that this is a tough skill to learn for anyone. It is often a lifelong pursuit to reach the level of mastery, so don't get discouraged if your first attempts are unsatisfactory!

"Details make perfection and perfection is not a detail."

Leonardo Da Vinci

INDEX

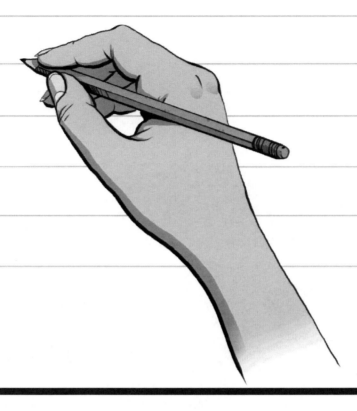

CHAPTER 1
ERGONOMICS

In this chapter you will learn about the most healthy sitting posture while drawing, how to orient your paper, and how to hold your pencil to achieve the best lines. It's important to learn this stuff even before you pick up the pencil to draw for the first time!

Don't skip this!

DRAWING POSTURE

DO THIS BEFORE YOU START!

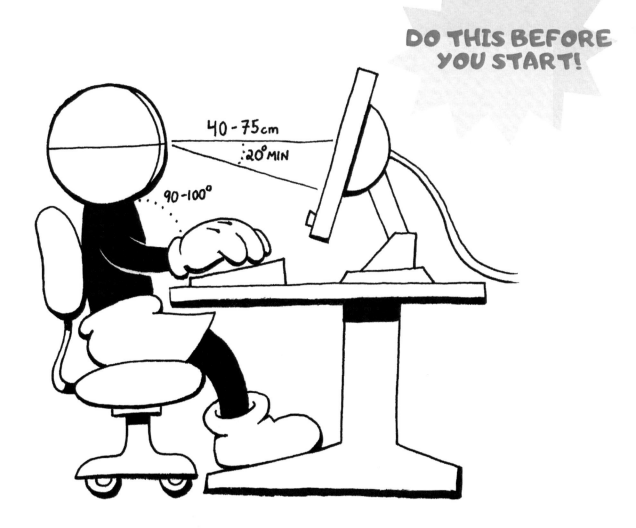

DRAWING WHILE SITTING

Most of our drawing and writing is done while sitting at some kind of table. We do it our whole lives and it is VERY easy to get into some bad habits. It can lead to long term effects like back, neck, and shoulder pain. It has short term effects too such as affecting the quality of your lines. Make sure you have a healthy posture when doing either of these activities because it limits the movement of your pencil if the stabilization of your arm is incorrect.

When sitting, your feet should be flat pointed forwards, slightly

ahead of your knees, not crossed. Your knees should be at the same elevation as your hips. Your arms should be bent at the elbow (90-100 degrees) and resting on the table to avoid unnecessary shoulder strain. They should be relaxed and not scrunched up toward the ears. Your neck is the most tricky part of your body to keep in line because many of us have a tendency to crouch down over time closer to our pages. When you straighten your back, your neck will automatically prop your head up. Begin in this position but allow yourself a small, but comfortable downward angle to view your page. Avoid a full downward extension. If it is required to see your page, you will need to adjust your chair or table height. Keep a viewing distance of your page to about 1'. Keep it close to the edge of the table so you have as close to a top-down view of your drawing as possible. This may seem trivial, but if you have your page too far away it is easy for your drawing to become skewed due to your perspective. It can look great as you draw it but once you pick it up you'll immediately notice that it looks nothing like how you thought it did. Its completely due to your angle of view as you draw. To remedy this, there is a special table known as a drafting table that allows for the artist to create a custom tilted surface using a handle. This will allow for 2 things: an instant reduction in neck strain, and you will get even closer to having a top down view.

As you draw, you may find the tendency to contort yourself into strange poses to get the right arm positions to make the line you need, but you shouldn't do this! The best way to fix this problem is to constantly turn your page as you draw so you can maintain the right posture. Your lines will also be better as a result.

FOR DRAWING, USE THE SAME POSTURE, ALTHOUGH YOU CAN MOVE HEAD FORWARD TO LOOK DOWN AND IT IS BEST TO USE AN ANGLED DRAWING TABLE.

If viewing a computer monitor to do design work or researching image references, make sure your chair is at the right elevation to bring your eyes in level with the top 1/3 of your screen if you look straight on. This will alleviate you from have to crane your neck to look up or down too much for no reason. Stay at a viewing distance of approximately 1.5'-2.5' and keep the lights on in the room to avoid eye strain.

If you know you'll be working long hours, plan regular breaks into your day and include some simple stretches into your routine. It will allow you to clear your mind and keep your consistency!

HOLDING YOUR PENCIL

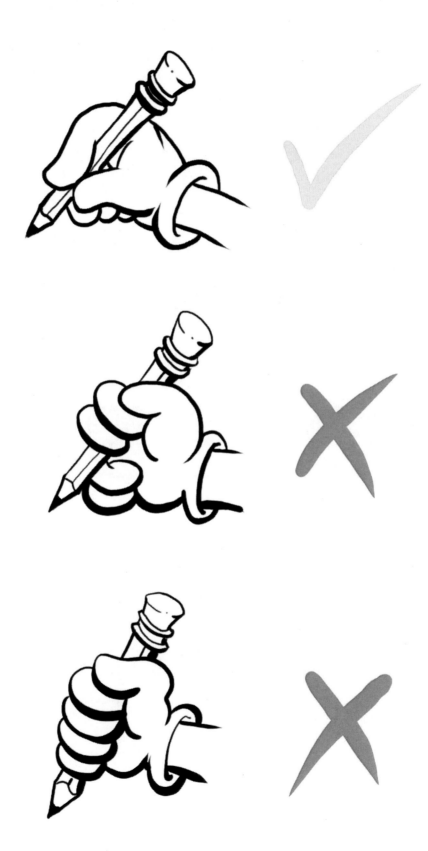

CHAPTER 2
DRAWING TOOLS

In this chapter you will learn about the best tools for a beginner to start off with to get the most encouraging results.

Remember, the tools don't make the artist, but they are necessary in producing professional quality work. I don't expect you go run out and drop $100 on new materials, however, you should make a small investment in a decent pencil, stack of paper, and eraser to give yourself the best chances of success!

PENCILS

Ok, so now you know how to sit while you are drawing, but what about the tools you should be using? Well, there is no definite answer to that because every artist has their own preference, but I have a few tools that I have come to enjoy due to their performance in achieving my style.

The first one is my trusty blue Staedtler lead holder. This is not your typical wooden pencil, rather it is a reusable holder made of metal and hard plastic. You put lead refills into it when you've used up all of your lead. It is comfortable and sturdy and you can get excellent Staedtler refill leads. I typically use 2H with this pencil. You will never need to worry about wood shavings again although it does require you to have the special lead sharpener. Another benefit of this pencil is that since you aren't sharpening it down, the length always stays the same to make sure you have optimal performance.

My second pencil is my Faber Castell 9000 Jumbo. It is an over-sized HB pencil that is great for loosely sketching in your drawing because it is so easy on the page. It's very easy to erase and creates a nice consistent line because of its quality Faber lead.

faber castell pencil

My third pencil is my Prismacolor Col-Erase. These come in a wide variety of colours and they are essentially erasable coloured pencils. I think they are great for doing initial sketches that you are going to ink later because they add a little bit of colour and vibrancy to your drawing and make it pop. If you use the non-photo blue, it makes your inking a complete breeze because unlike pencil, you can scan your inked image without erasing it and you can set it so it won't be detected by your scanner. In this course I will be using red.

ERASERS

My all-time favourite eraser is the Staedtler Stick Eraser. It is not your typical eraser because it is a plastic casing that you insert long white erasers into that you can keep pushing out. Personally it takes me about 6 months to go through one of these inserts and I draw a lot! Its small size allows you to do delicate erasing work and you can retract the eraser so when you store it. Because of the case, it stays clean of pencil lead, dirt, oils, and paint and otherwise contaminants that would be likely to streak across your page. Making you cry. You want your eraser to stay clean.

My second favourite eraser is a kneaded eraser. They are often times grey and look like stick tack. These are great for erasing large sections very lightly so you can still see the pencil lines enough to ink over top of them.

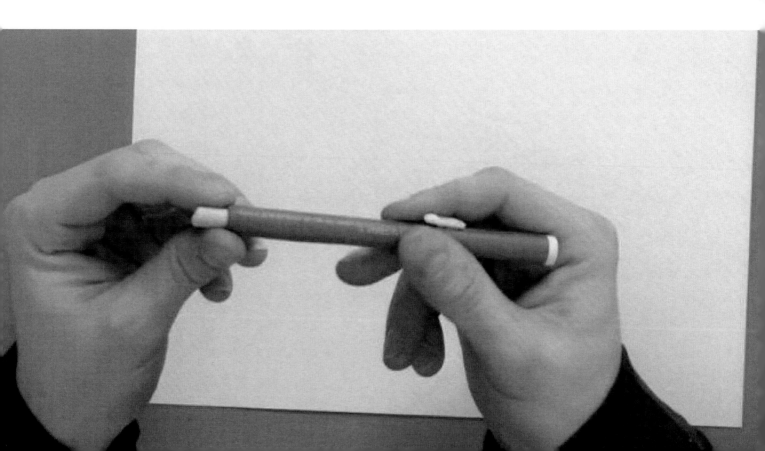

LINE GUIDES

A clear ruler is a necessary tool for any artist because it allows you to do **perspective drawings** accurately and allows you to see the lines beneath your ruler. It saves a tremendous amount of time and frustration.

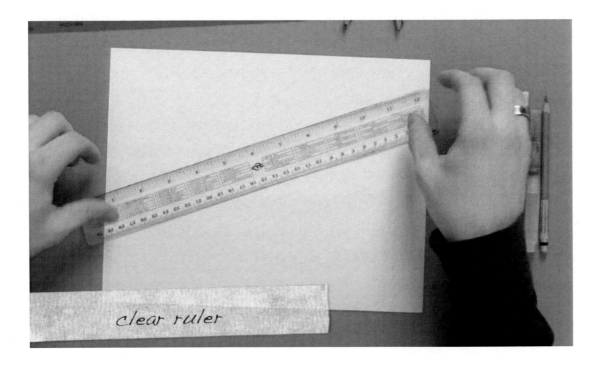

clear ruler

A circle guide is great, especially when drawing your character's head because you will get perfect circles every time!

PAPER

The type of paper you use is incredibly important, even as important as the type of pencil you use. It is as much of a part of the drawing as anything else. You can get bristol paper which is perfectly smooth, or you can get textured paper which is bumpy. Both will appear different to the eye and both will present different challenges in applying your chosen media depending on how you want it to look.

For a new beginner to practice, I always suggest to NOT use those normal sketchbooks you might find in the store. Typically they have some type of soft, bendy paper that is 65-90 lb (this is a rating found on the cover of each sketchbook or stack of paper telling you the thickness). After discovering 110 lb cardstock paper in the printer paper aisle (very inexpensive) I could never go back to drawing on that stuff. Cardstock paper is very tough and durable and lets your pencils and pens glide across the surface with ease. Your drawings will turn out much better!

PENS

If you are interested in making clean, black <u>line drawings</u> you will need to use a pen or a brush. You would use a program such as Adobe Photoshop if you want to do it digitally.

My #1 go-to pens are Sakura Pigma Micron pens. You can get them in all sorts of nib sizes such as 01, 05, and 08. The higher the number, the larger the nib and thicker the line. These are high-quality disposable pens that produce incredibly consistent lines both in terms of width and the <u>opaqueness</u> of the ink released.

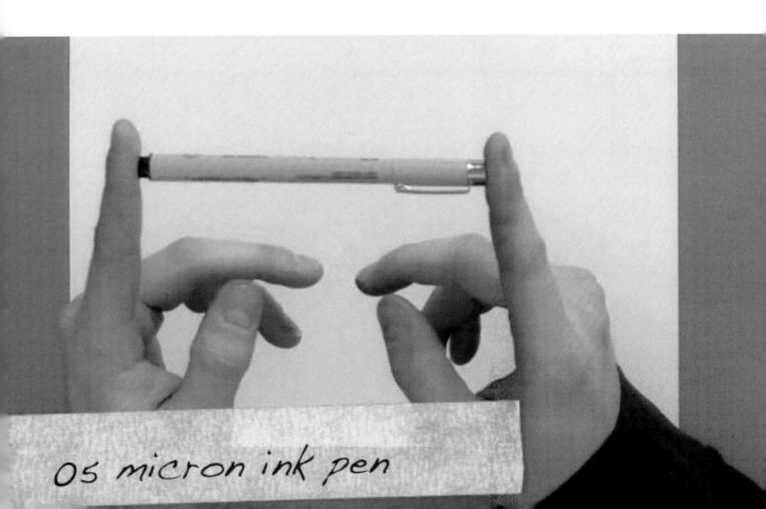

os micron ink pen

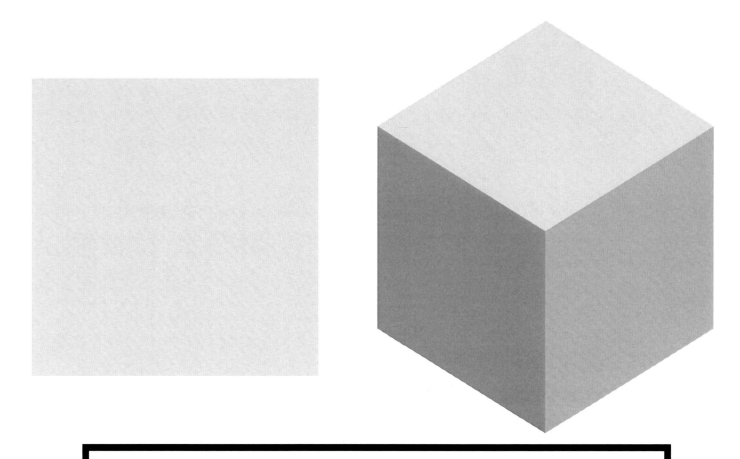

CHAPTER 3
BASIC 3D SHAPES

In this chapter I will show you how to draw basic shapes and get you thinking about them as malleable 3D forms that you can rotate in your mind.

These skills will help you in any drawing imaginable, from realistic to cartoon.

PYRAMIDS

I can hear the groaning already! And the answer is YES, you need to know how to do basic shapes. You need to be able to draw them from any angle without thinking too much about it. You must equate it to learning how to walk before you can run.

Even for drawing cartoon characters, this will give you almost everything you need to start making up poses from your head.

To begin, a pyramid is a 3D shape made of five 2D shapes. 1 square and 4 triangles.

TOP

TILTED ANGLE

STEP 1

Draw the square base of the pyramid using a **parallel** skew of the sides. Remember that the opposing sides are paralle to eachother unless going to a vanishing point.

STEP 2

Draw a dot in the center of your "parallelogram" and gently press your pencil to draw a **guideline** to the top of the peak. This is where all of your trangular edges will connect up to. To assist you in predicting the peak, imagine an invisible arc between each corner.

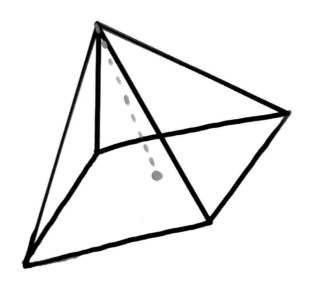

STEP 3

Draw <u>interior contour lines</u> to define your shape in order to understand the surface. You can do this with all of your shapes if you are interested in practicing them and mastering them!

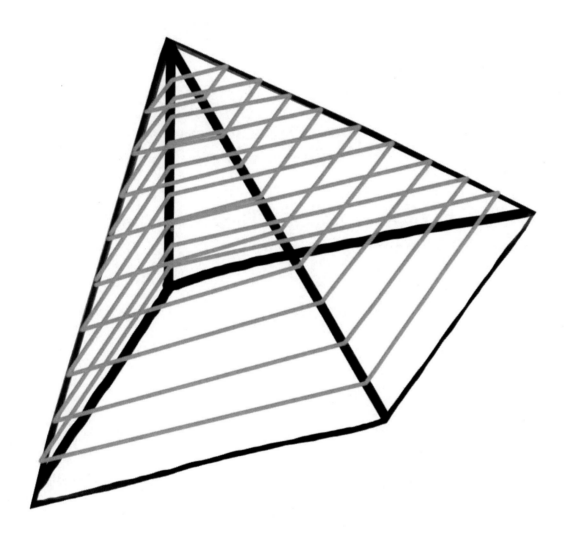

CYLINDERS

A cylinder is a 3D shape made of three 2D shapes. 1 rectangle and 2 circles.

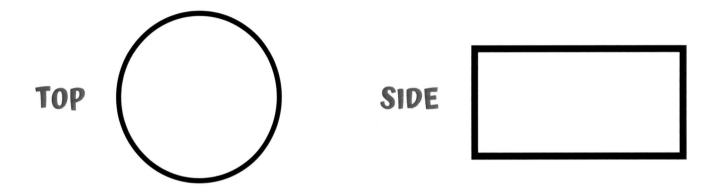

TOP

SIDE

To draw the direct top of a cylinder, take your circle stencil and draw a circle of the desired width of your cylinder.

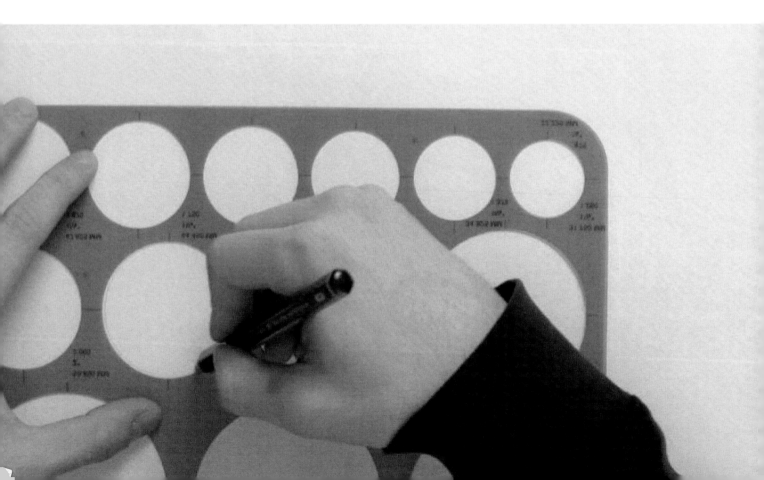

TILTED ANGLE

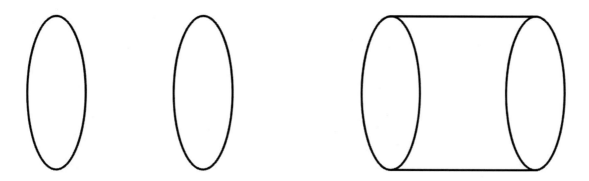

STEP 1

Draw two ellipses of the same width next to eachother. You can determine the width by how much you want the cylinder to be tilted away from your eye. The rule of thumb is, the skinner your ellipse is, the more of the rectangle is visible to you, until it is a 90 degree edge. At that point your cylinder will simply appear as a rectangle.

STEP 2

Draw 2 parallel connecting lines between the tops of the ellipses. These are the outside edges of your rectangle.

STEP 3

Draw interior contour lines to add <u>dimension</u>.

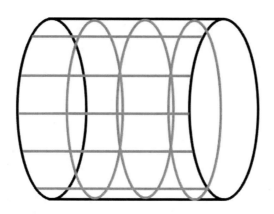

SPHERES

A cylinder is a 3D shape made of a single 2D surface.

TOP/SIDE

The top of a sphere is the same as the side. You can draw this with the circle stencil.

To show dimension, add two overlapping ellipses for interior contour lines.

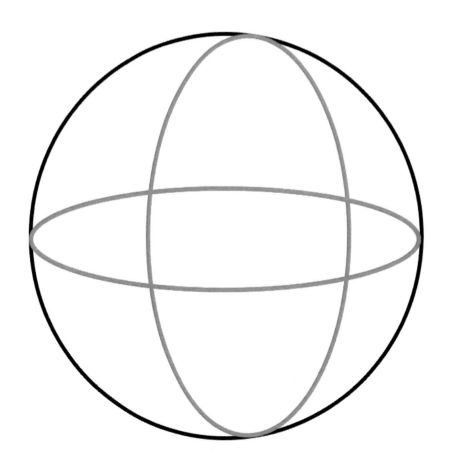

CUBES

A cube is a 3D shape made of six equal 2D squares.

TOP/SIDE

The direct top and side of the cube will appear as a simple square.

TILTED ANGLE

STEP 1

Draw a square.

STEP 2

Draw another square behind your first one. This will determine the front and back faces of the cube. The position of their relationship will determine the angle of the top face in relation to your viewpoint.

STEP 3

Draw 2 sets of parallel connecting lines between the tops of the squares. These are the outside edges of your other squares.

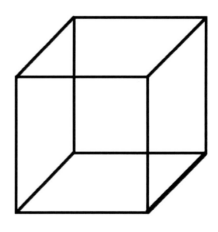

STEP 4

Draw interior contour lines to show dimensions.

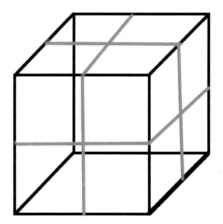

CONES

A cone is a **3D** shape made of a circle and an **irregular Polygon** that connects to a single point above the center of the circle.

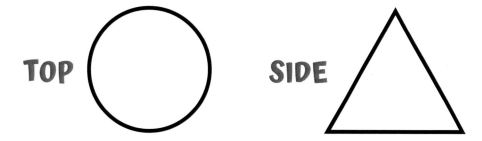

TOP SIDE

The direct top of the cone will appear as a circle and the direct side will appear as a triangle.

TILTED ANGLE

STEP 1

Draw an ellipse for the base. The squish of your circle will determine how far it is tilted from your eye from the top down and the angle between the apexes will determine the tilt.

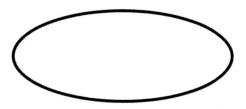

STEP 2

Draw a dot in the center of your ellipse and gently draw a guideline to the top point of your cone. Use the angle of your apexes to eachother to help you find the point.

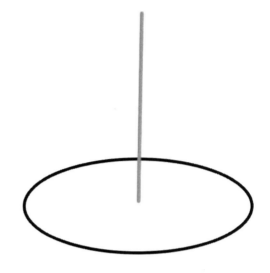

STEP 3

Draw two connecting lines from your point to your ellipses apex curves.

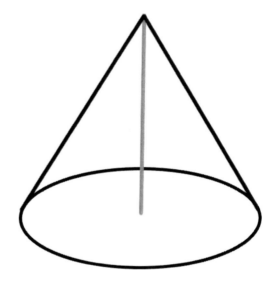

STEP 4

Draw interior contour lines to show dimension.

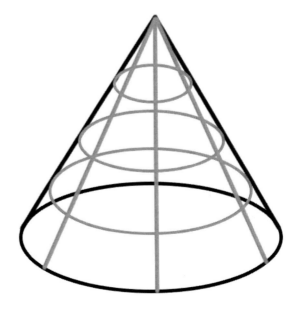

CHAPTER 4
STICKMEN

In this chapter I will be talking about my completely new way to think about stick people and how you can finally learn to upgrade yours so it takes the shape of your first cartoon character, Tommy Toon.

I've designed Tommy as your own personal secret weapon. If you study him closely, he will give you the power to create your own cartoon characters in the future!

1.5 DIMENSIONS

I believe that people who think they only have the artistic talent to draw a stickman are actually just lacking knowledge and a little practice. I think everyone is capable of learning what I am about to show you because it is so simple. All I am asking is that you consider for a second that you may just have 1 artistic bone in your body.

First we need to understand the stickman. I look at a stickman as only really being in the 1.5 dimensional world, he hasn't quite fully transitioned to 2D. He's somewhere between 1D and 2D. His arms, legs and body exist in the 1D world and only his head is in the 2D world.

2 DIMENSIONS

If we add width and a bit of pinching to each of the 1D shapes on the stickman, we create something very, very different. We will have a character that has fully transformed into 2D.

The only part kept the same here will be the head, but we will add crosshairs on the face which will help you later in placing the eyes and facial features. Using the closest geometric shape to a line as possible, I transformed the body, legs, and arms into rectangles. Additionally I have added circles for the base of the hands and two doubled up circles with a flat bottom for the feet.

Congratulations on your first step!

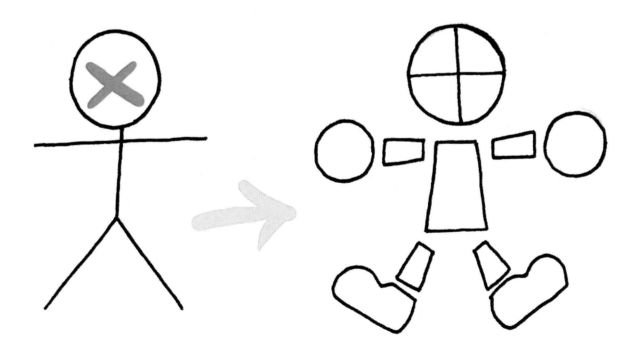

3 DIMENSIONS

To bring your stickman 1 dimension further, you need to add depth to your shapes.

I have transformed all of the 2D rectangles into the closest 3D shape besides a rectangular prism, cylinders. Historically, many of the big cartoon characters in the early days such as Felix the Cat, Mickey Mouse, and Oswald the Rabbit use soft edges over hard edges in nearly all cases on their characters. Follow their lead when designing your own, it gives a very friendly and whimsical quality to your creations.

For the head I have further imagined it as a sphere. The hands and shoes have also taken on sphere-like qualities. The cufflinks are donut shapes (torus) and are essentially cylinders I have added. The difference between a torus and a cylinder is that a torus has no circle faces, they are merged. His fingers are sausage shapes. I then merged all of the separate shapes with smooth, <u>organic lines</u> and even gave him some shorts!

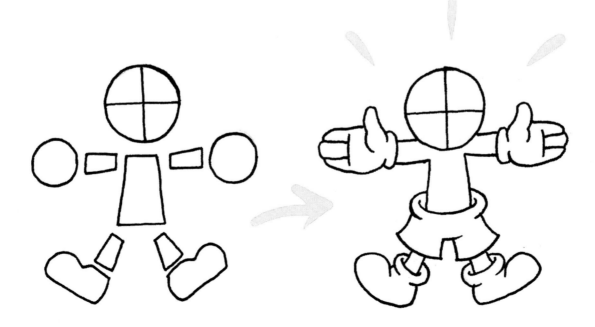

One very important part about creating Tommy is his proportions. Even when we draw realistically, we always measure the human form in a head count. This means that first you want to start by drawing the head and then using that as your measuring tool to figure out where the arms extend to, where the waist is, and where the feet are. Typically, a human is 7 "heads" tall. To make someone look more heroic, you may choose to extend it to 8 heads.

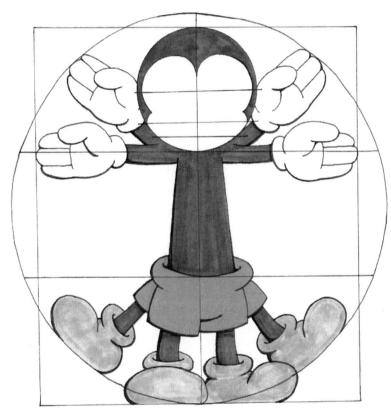

For Tommy, we are going to use some cartoon proportions and use 3 heads. The 2nd head will mark out the waist and the 3rd head will mark out the bottom of the feet. Draw little tick marks to map it out on your page before you add in your body and feet. On the next pages I will show you some popular cartoon characters, try to figure out their proportions!

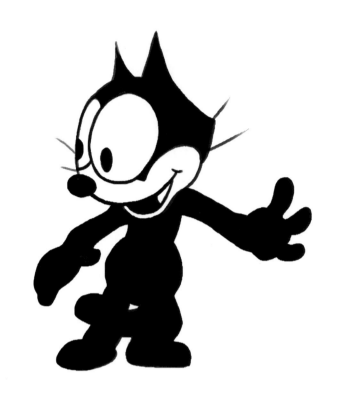

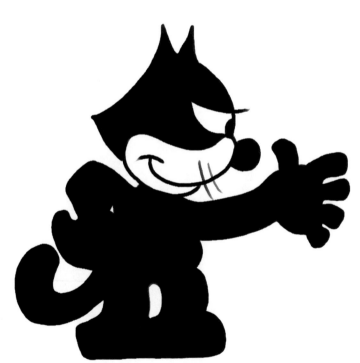

FELIX
THE CAT

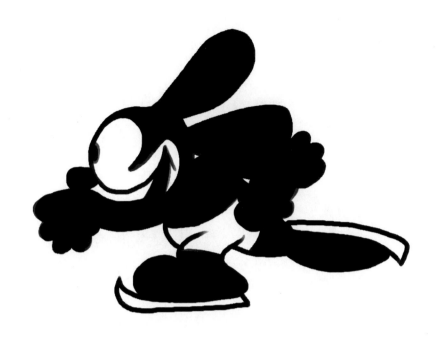

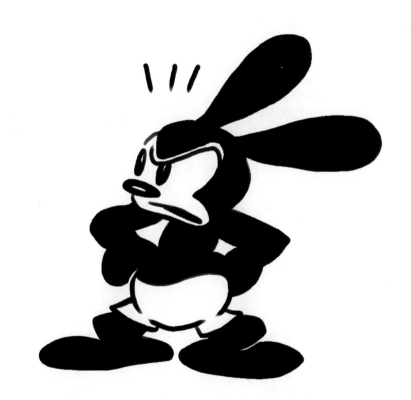

OSWALD THE LUCKY RABBIT

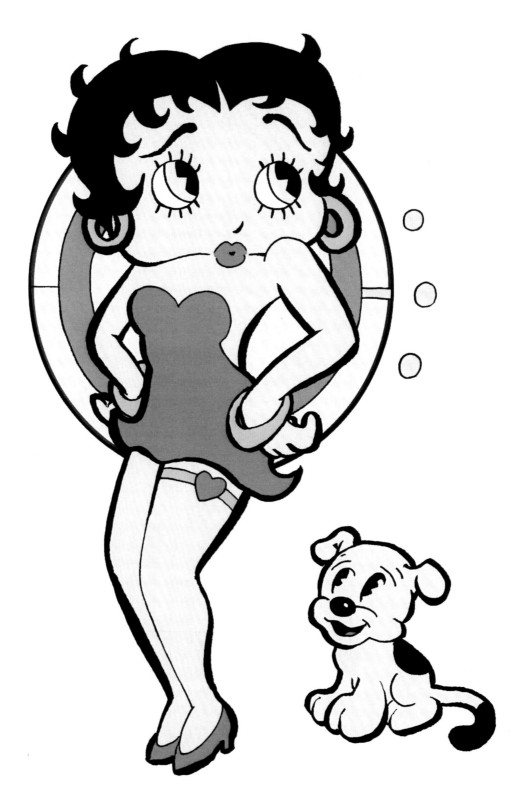

BETTY BOOP

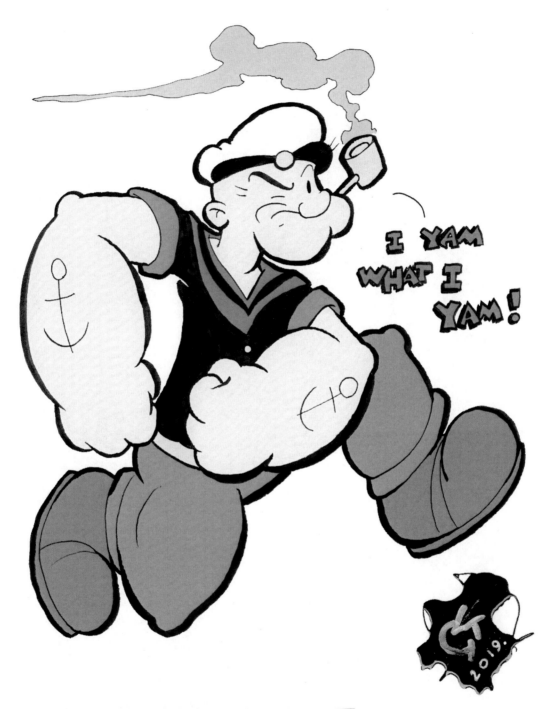

POPEYE THE
SAILOR

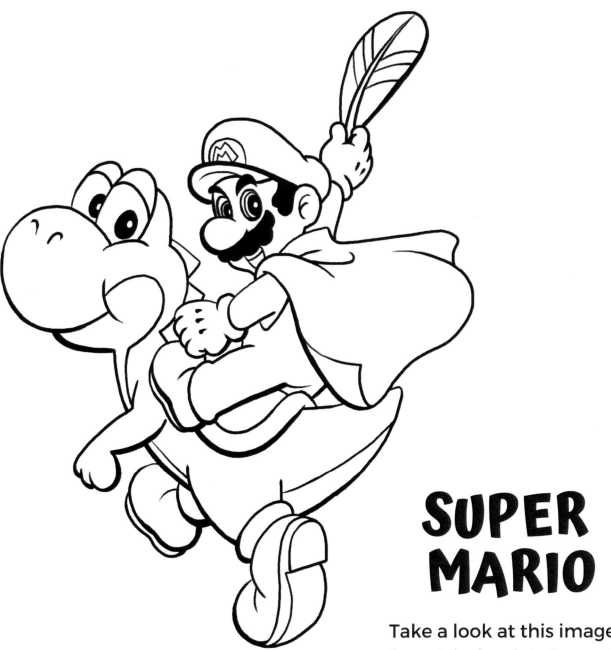

SUPER MARIO

Take a look at this image from Nindendo's Super Mario franchise. Notice how Mario uses the 3-heads tall proportions, gloved hands, and simple features. Even Yoshi has the cartoon shoes! Very consistent with 1930s animation and techniques that I have been showing you!

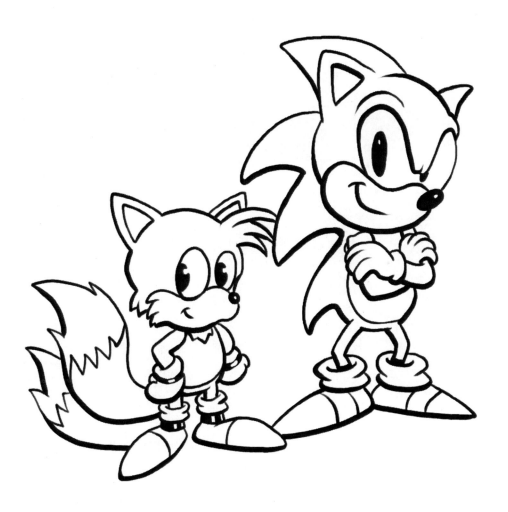

SONIC THE HEDGEHOG

The same goes for Sega's Sonic the Hedgehog and Tails! Do you notice the similarities between these character designs, Mario and the 1930s cartoons?

I'll give you a hint: 3 heads tall, gloved hands, and simple features!

Is this starting to make sense?

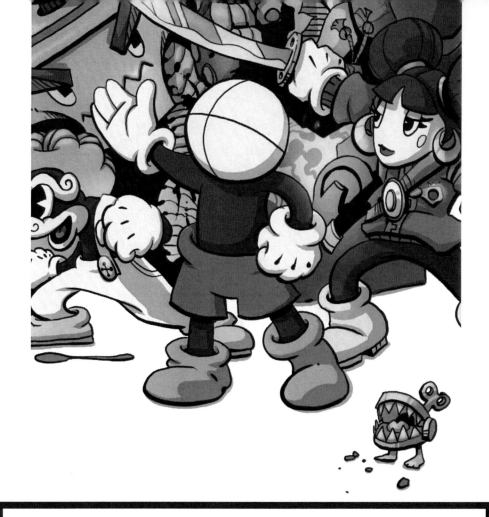

CHAPTER 5
TOMMY TOON

In this chapter I will demonstrate for you how to draw a 3/4 view of
Tommy Toon from scratch!

Don't forget to watch the live demo of this in the video course!

GUIDELINES

Before we entirely discard the stickman and his hold over your life, there is actually one very important use for him!

A slightly modified version with some extra details serves as a very effective means of blocking in the initial <u>rigging</u> to hang your shapes off of. Imagine it as the metal wires that go through the center of a clay sculpture,

You should sketch this 'skeleton' in very lightly before anything else goes down. Make sure you pay attention to the proportions and the relationships between the sizes of the circles and where they meet the division lines!

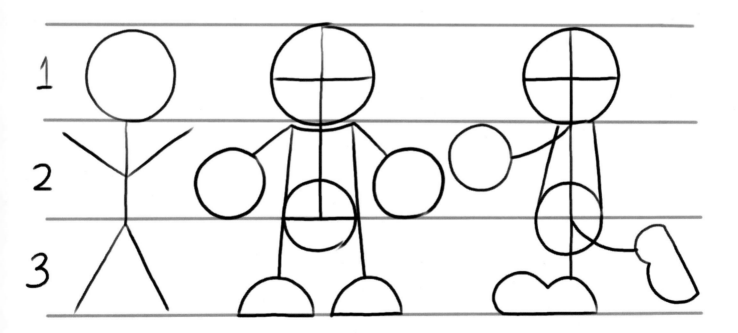

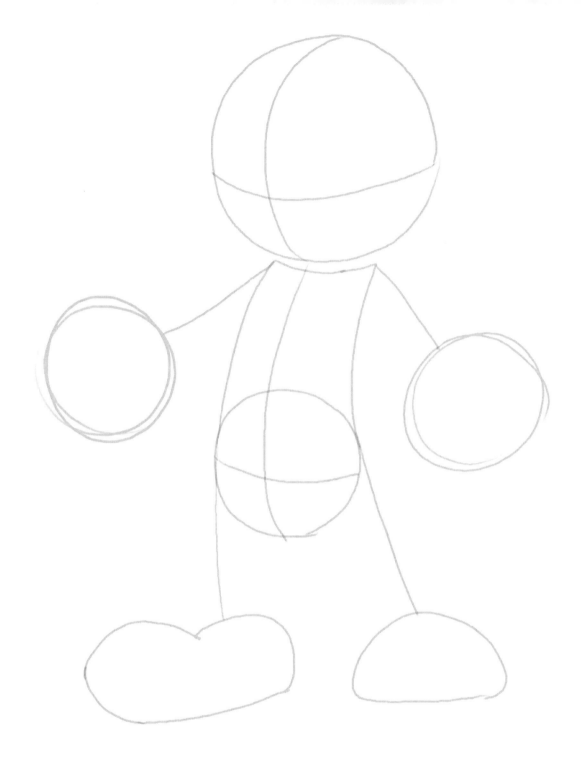

For this demo, I am going to go a step further and bring our stickman "Tommy Toon" into the 3D world! This is a dynamic view is known as a "3/4 view" and it is meant to show off our character on an angle. Here I've drawn the same framework, just with some curved tweaks in the lines to make Tommy more lively and animated.

We are drawing light guidelines at this point so we can lay the groundwork for our finished dark lines. This gives a neater drawing in the end because we can erase these early lines easily.

If you are drawing with a pencil, you can use a circle stencil for Tommy's head.

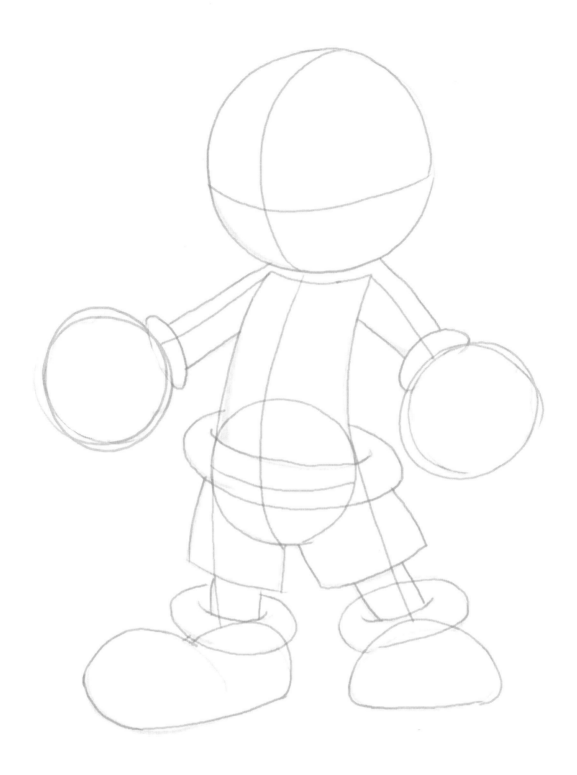

Add in further details like his cuffs and waistband with ellipses, sketch in his shorts, and then thicken his arms and legs into cylinders.

Double check the proportions of your character. You have about 1/3 of a head to play with before the proportions start to look off _balance_.

The cartoon hands are built off of the circles and ellipses which make up the palms. Fingers are simple sausage shapes that bend like macaroni (as do all of the joints in the character). Geometrically they are cylinders with spherical caps on them to give them the rounded tops. Put cuffs around the gloves, shorts, and shoes.

FINAL LINES

When your guidelines are complete and you are happy with your placements it is time to come in with your final lines.

Your primary job here is to create confident, crisp lines and establish a heirarchy of shapes. What I mean by this is that you need to highlight which shapes are over top of eachother by <u>overlapping</u>.

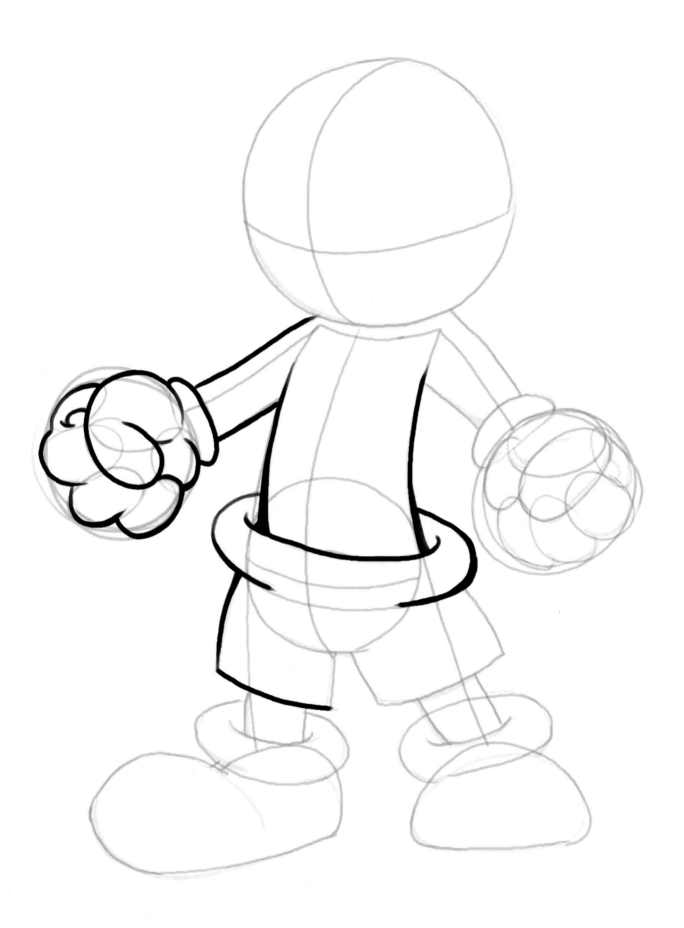

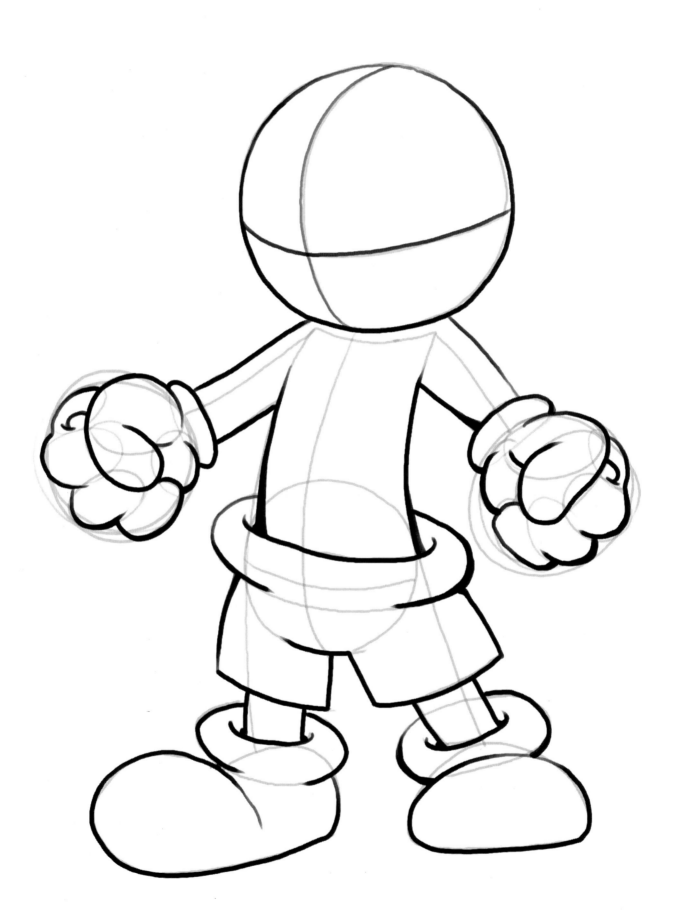

ERASING GUIDELINES

Great job! You got this far.

The only thing left to do now is to erase your initial guidelines and you are finished!

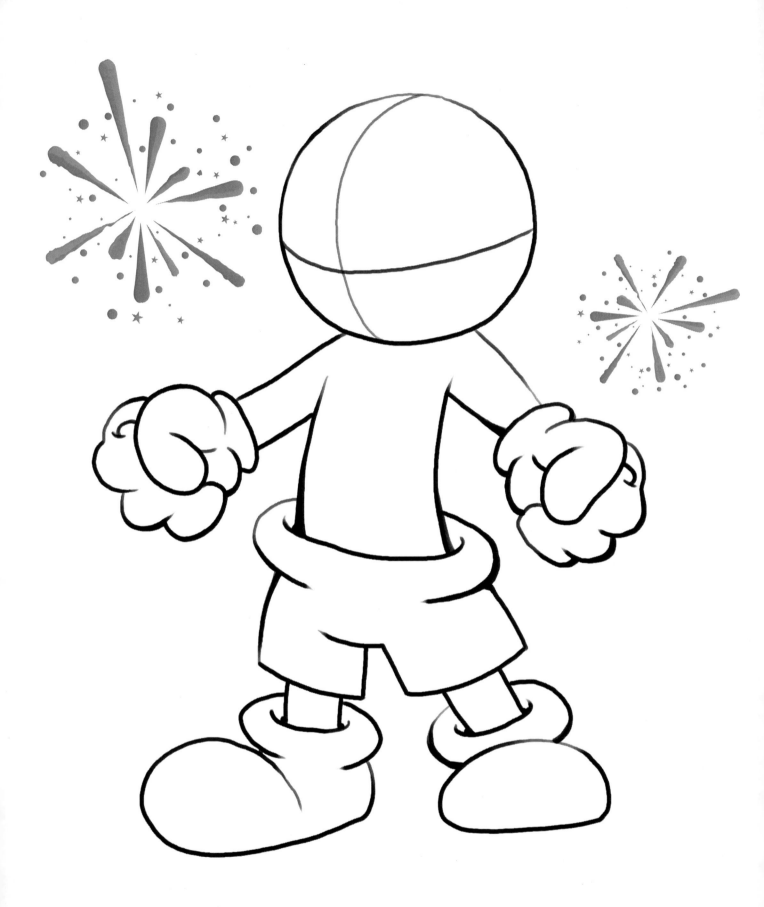

COMPLETE!

CARTOON BOY EYES

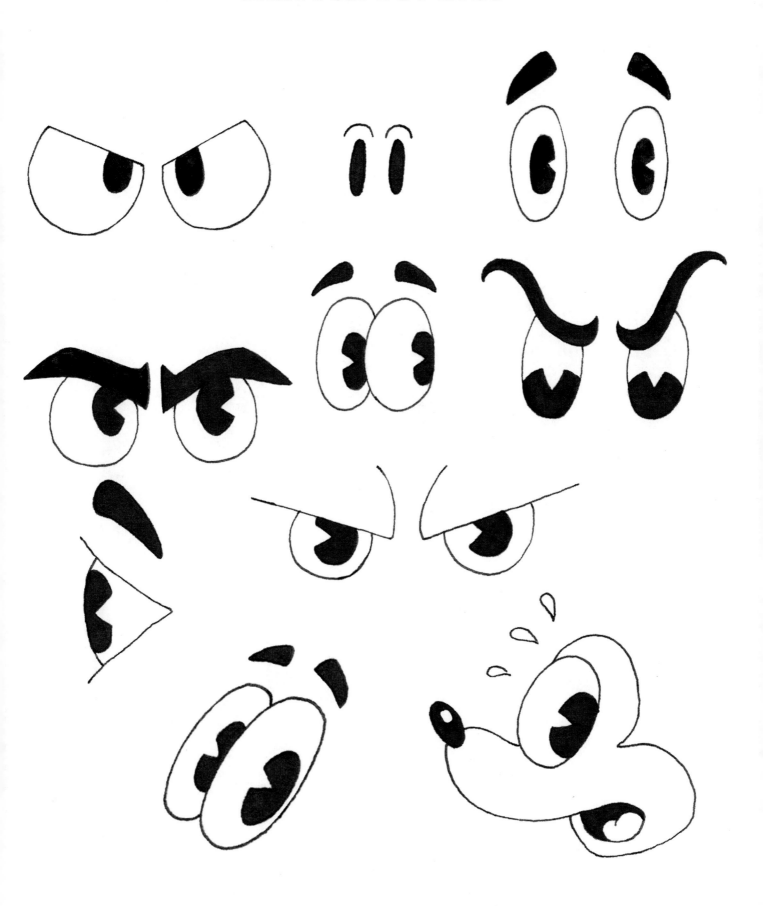

CARTOON GIRL EYES

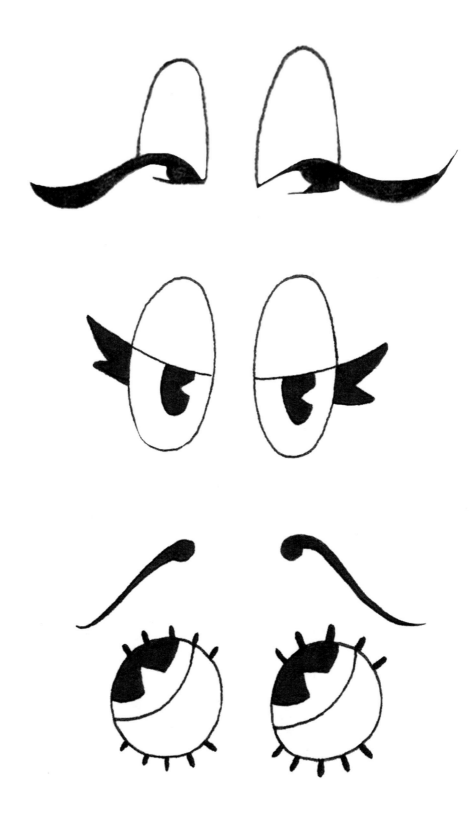

CARTOON MOUTHS

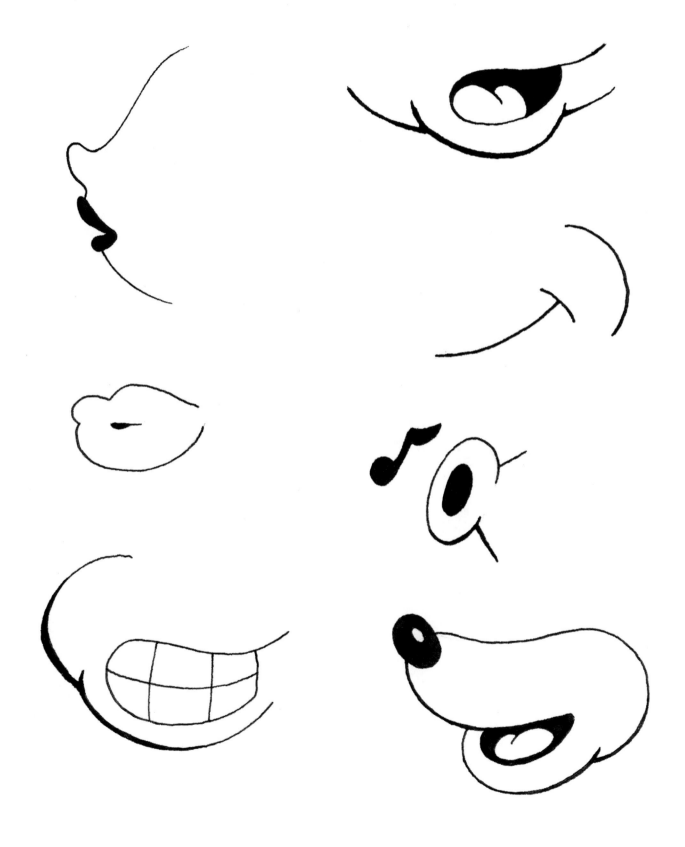

CARTOON EARS

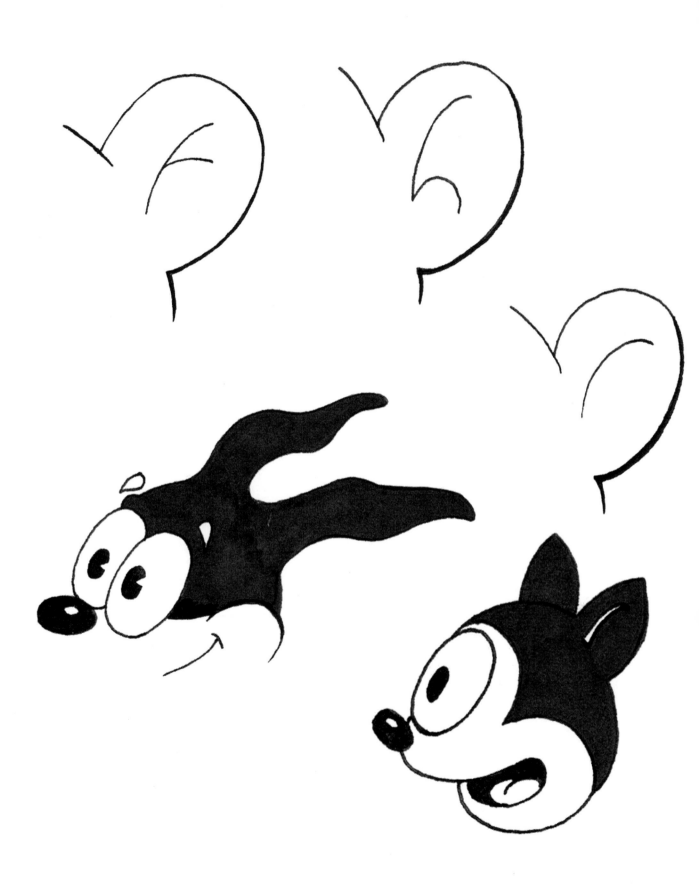

TOMMY TOON

DRAW THE FACE WORKSHEET #1

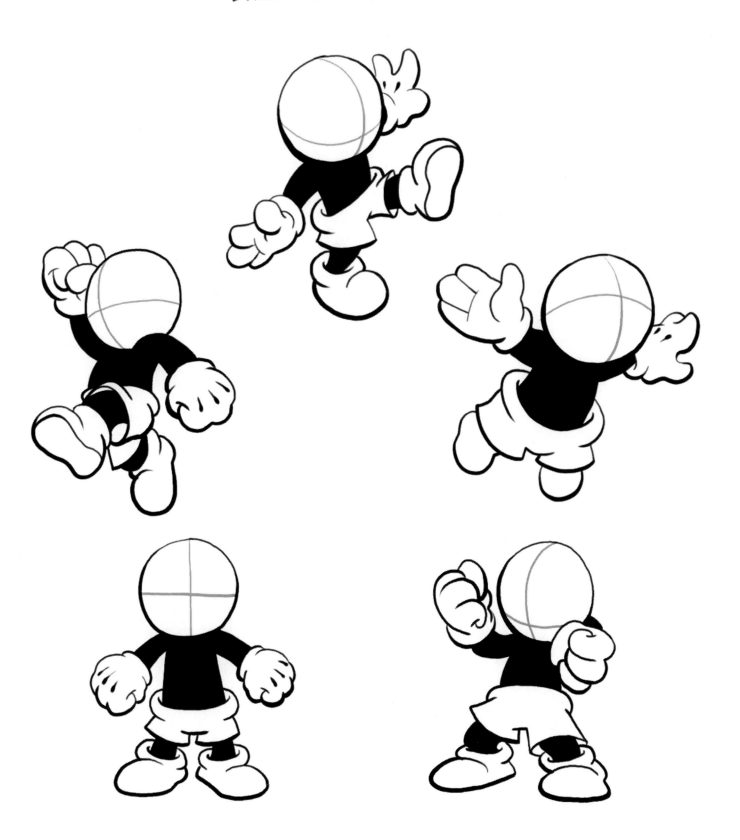

Tommy Toon

DRAW THE FACE WORKSHEET #2

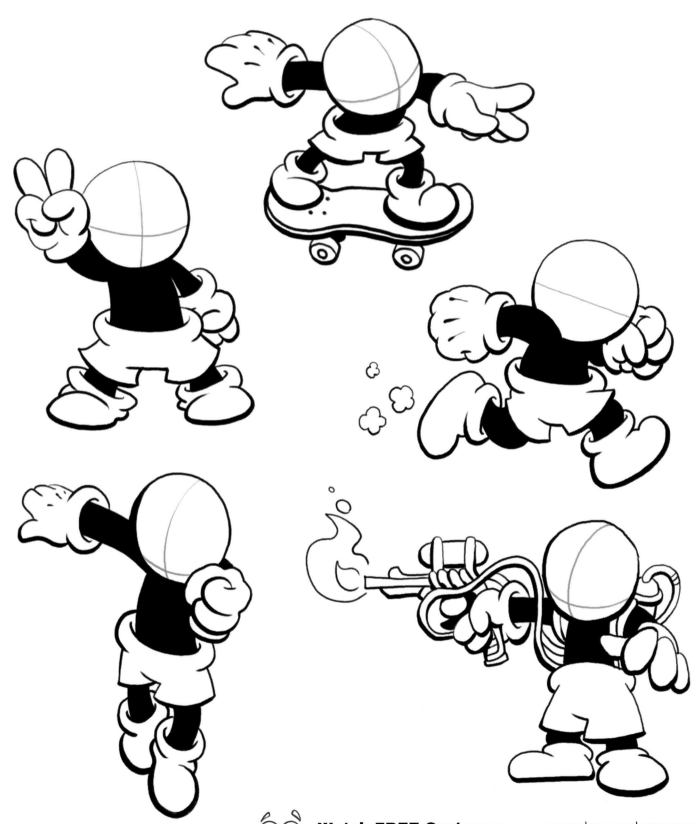

TOMMY TOON

CONNECT-THE-DOTS

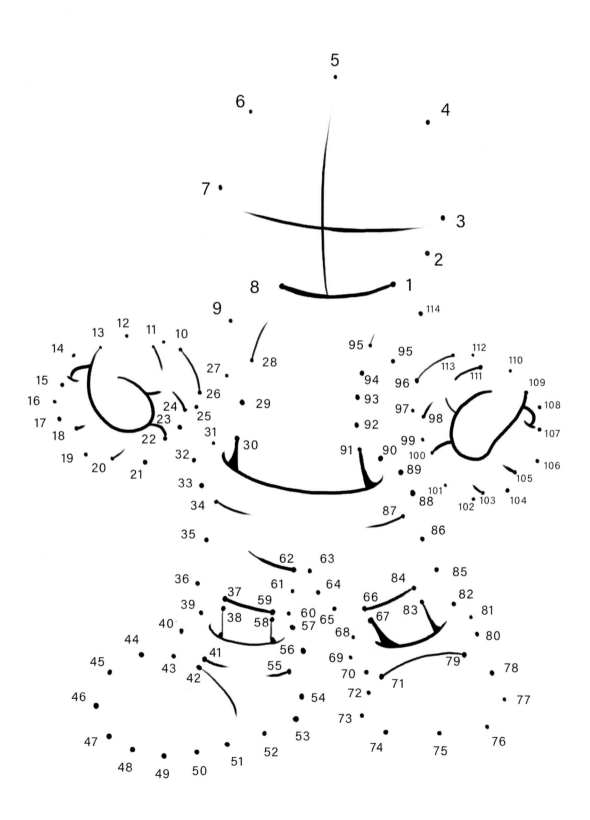

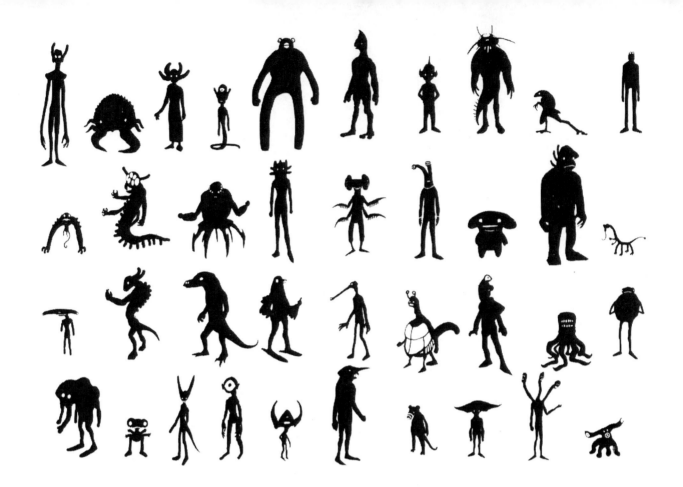

CHAPTER 6
CREATURE DESIGN

In this chapter I will be teaching you how to use the skills you've learned throughout this course to create your own original monsters!

Pick and choose which creature features you want and piece them together using the same process as you used for Tommy Toon.

MONSTER DESIGN

The best way to design a character is to establish its look with these 4 views.

3/4	FRONT	PROFILE	BACK
This view shows your character on a 45 degree angle.	This view shows your character from the direct front.	This view shows your character from the direct side.	This view shows your character from the direct back.

HOW TO CONSTRUCT:

1. CHOOSE A BODY TO START!

2. ADD SOME ARMS AND LEGS!

3. POP ON A HEAD WITH EYES, EARS, MOUTH & NOSE!

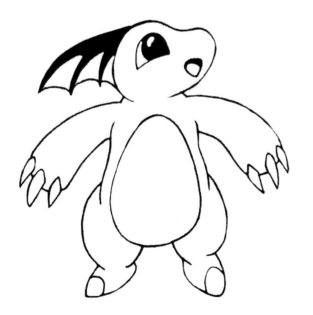

4. FINISH WITH SOME SPECIAL FEATURES!

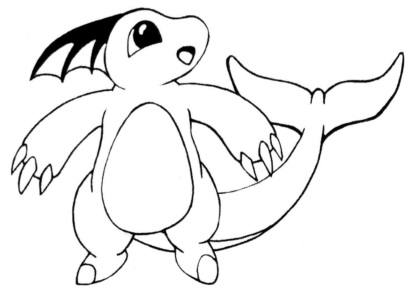

You need to think about overlapping when piecing your monsters together. You may also need to erase lines on the torso like I did in STEP 2 to make parts look like they are connected in front or behind. On the next pages you will find a ton of awesome monster parts to get you started!

CREATURE ARMS/LEGS

The diagram below will show you how to create a bipedal monster. Choose from the selections of arms and legs below and attach them to a torso of your choosing! Then you will be ready to add the hands and feet.

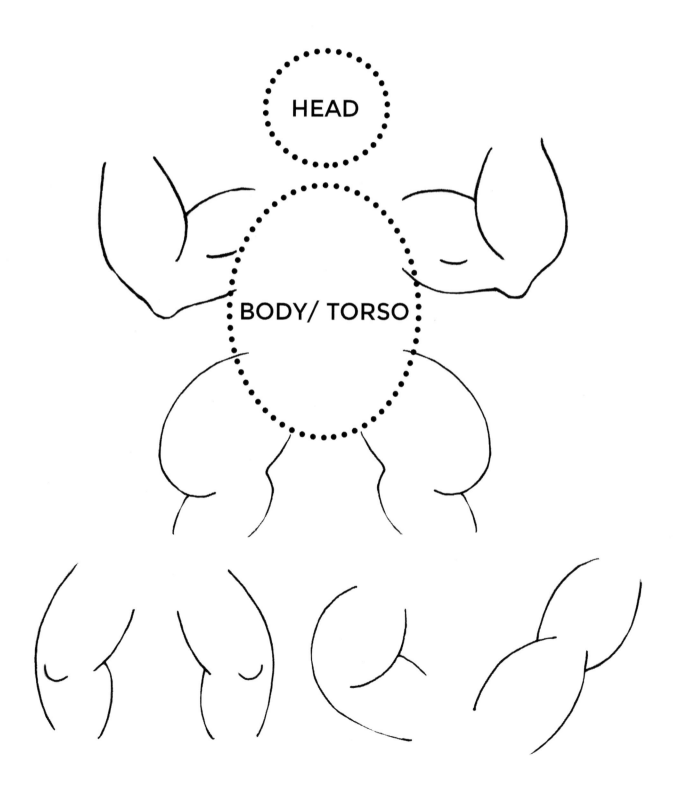

HEAD

BODY/ TORSO

CREATURE EYES

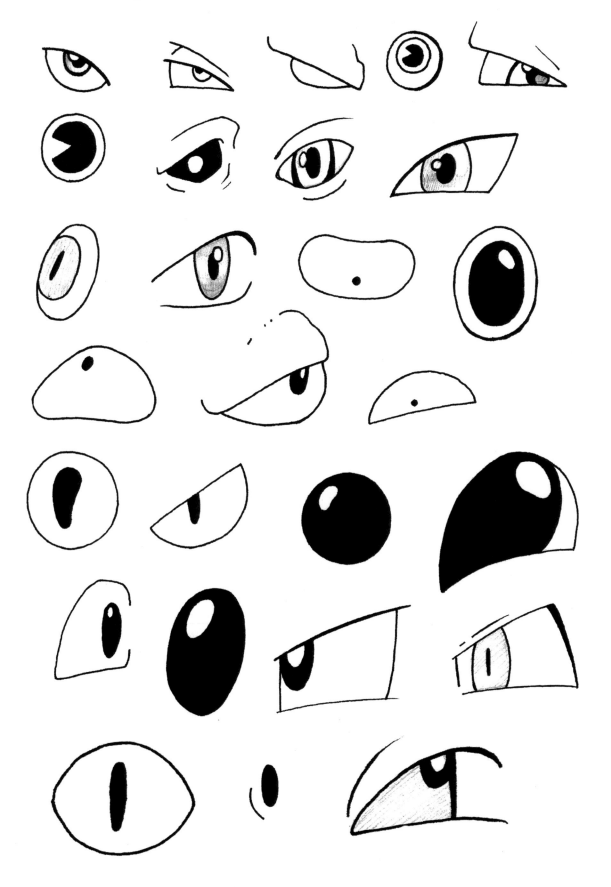

CREATURE PARTS

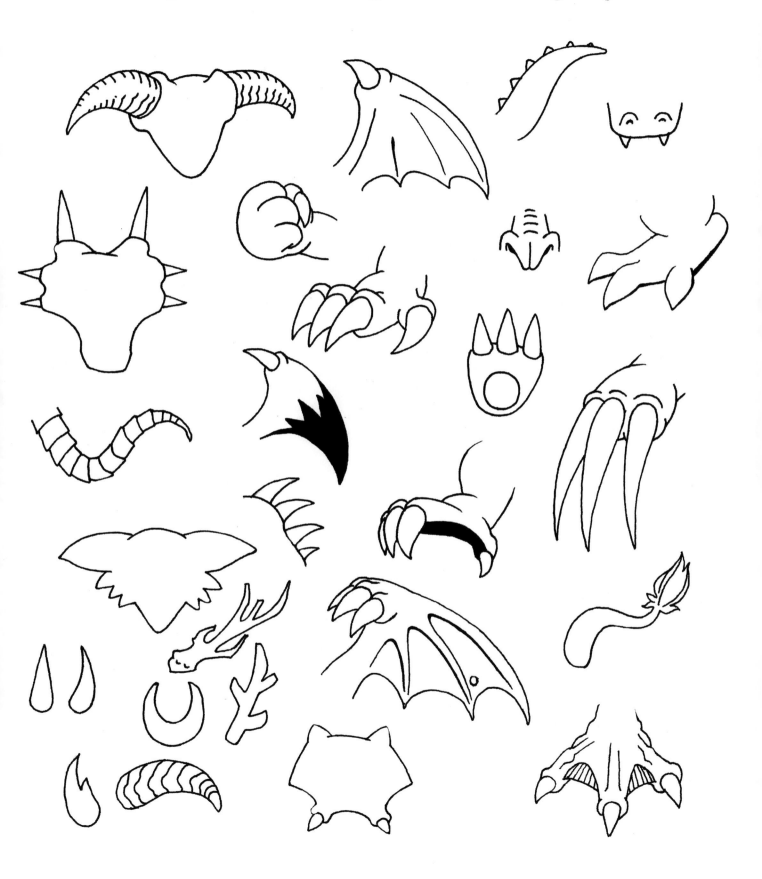

CREATURE PARTS 2

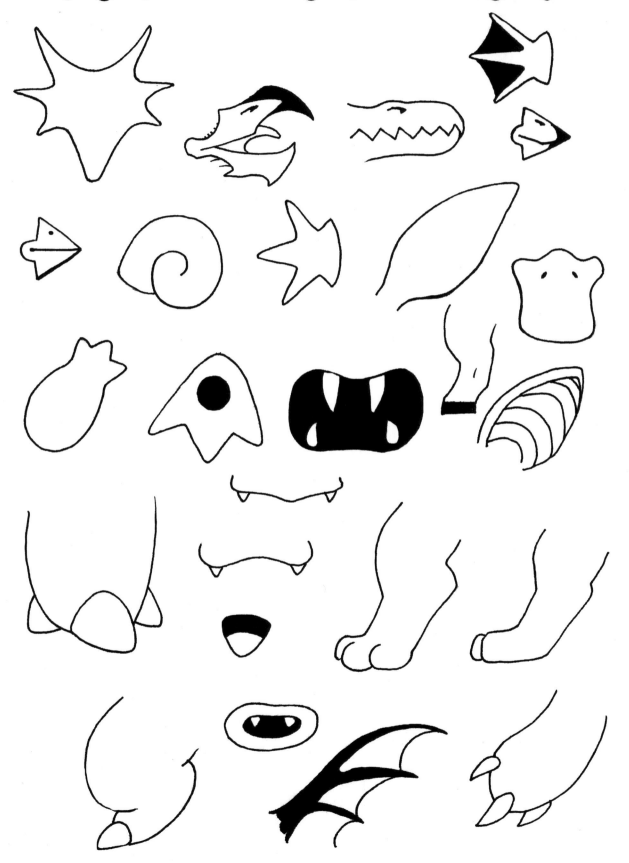

CREATURE PARTS 3

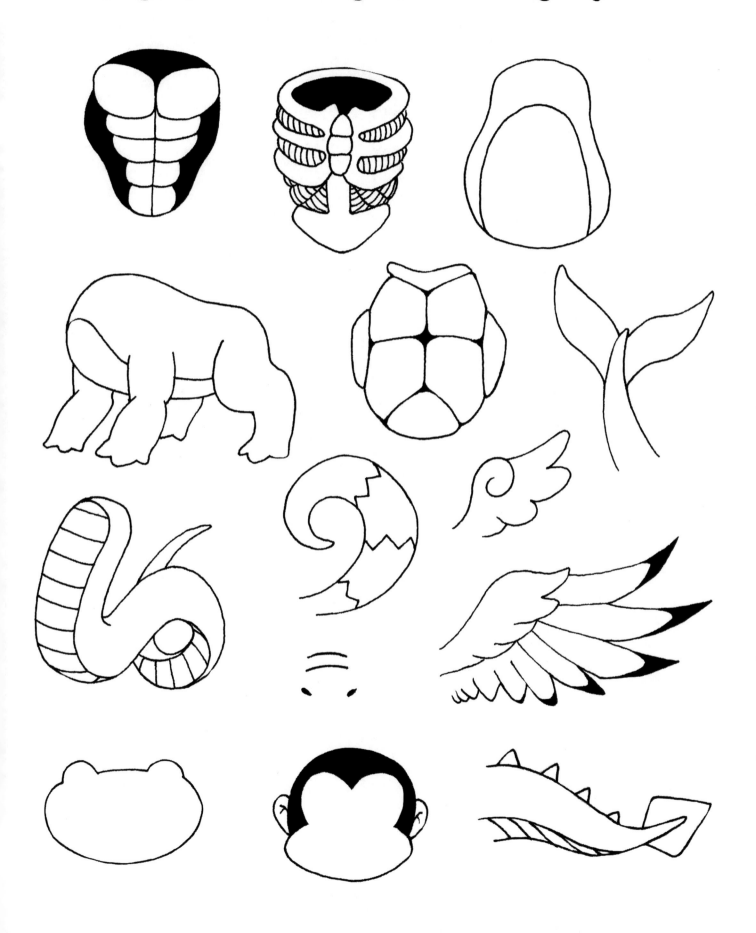

EXAMPLES

Here are some monsters that I've designed! Can you tell which parts I used? See if you can make some of your own!

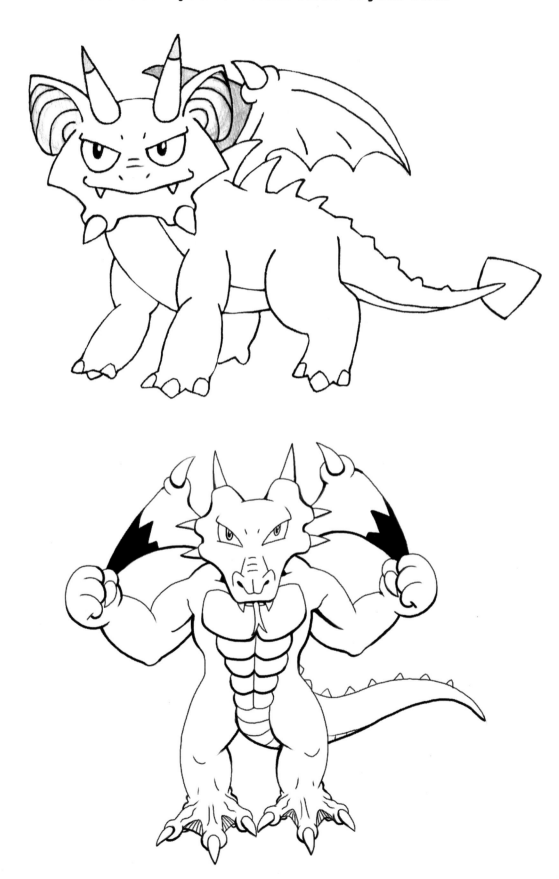

CHAPTER 7
INKING

In this chapter you will learn about the process called inking.

Most professional comic illustrators are able to bring their work to the next level and apply pen and ink to their pencil lines. This gives it a clean-cut finished quality that is unbeatable.

APPLYING INK

The first step, which I have shown in the previous chapter, is always the initial step to inking. You always need either rough guidelines or clean linework to begin. In the professional world, especially if a comic book has a team working on it, the **penciller** will make their pencil lines extremely clean before passing them to the **inker**. Since I am working on my own designs, I have created a rough sketch here of Tommy Toon knocking out Master Mushroom with a flying punch.

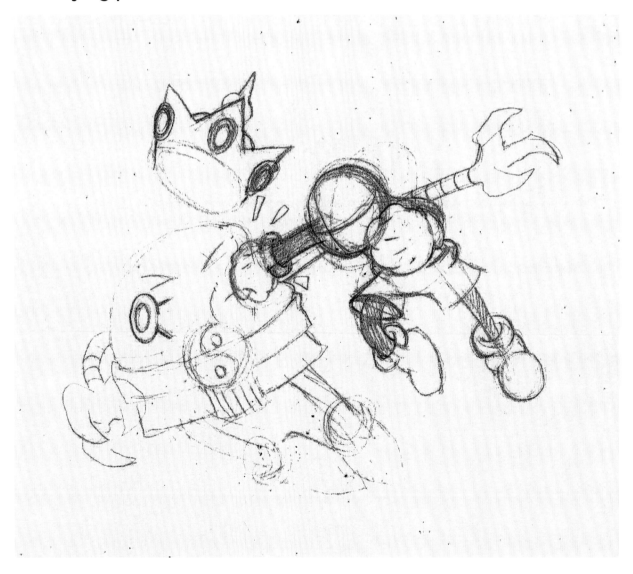

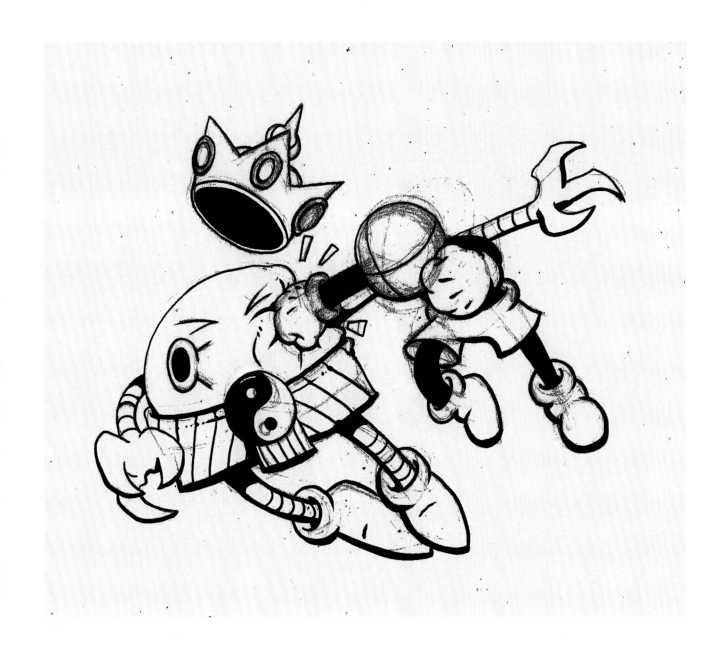

At this point you can see that my black inks are standing apart from the messy sketch I had initially.

If you have a result like this you know you are on the right track, all it needs is a little cleanup.

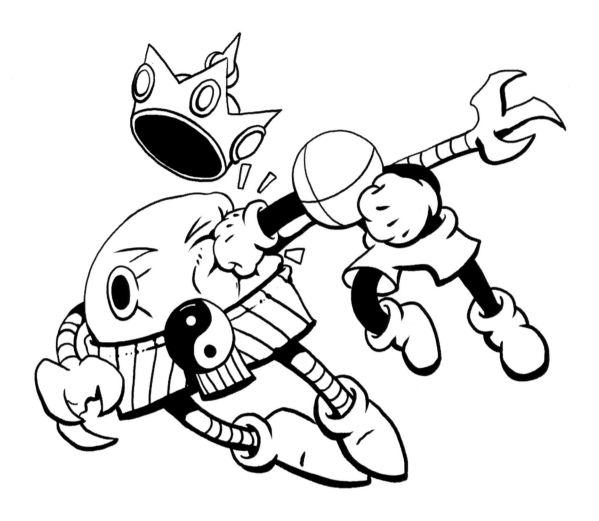

Can you tell the difference?

It's no wonder inking is so popular!

In this image I have completely erased my initial guidelines done in pencil/ coloured pencil. I dont stop erasing until only the inks are left.

I can now use this image as it is or colour it.

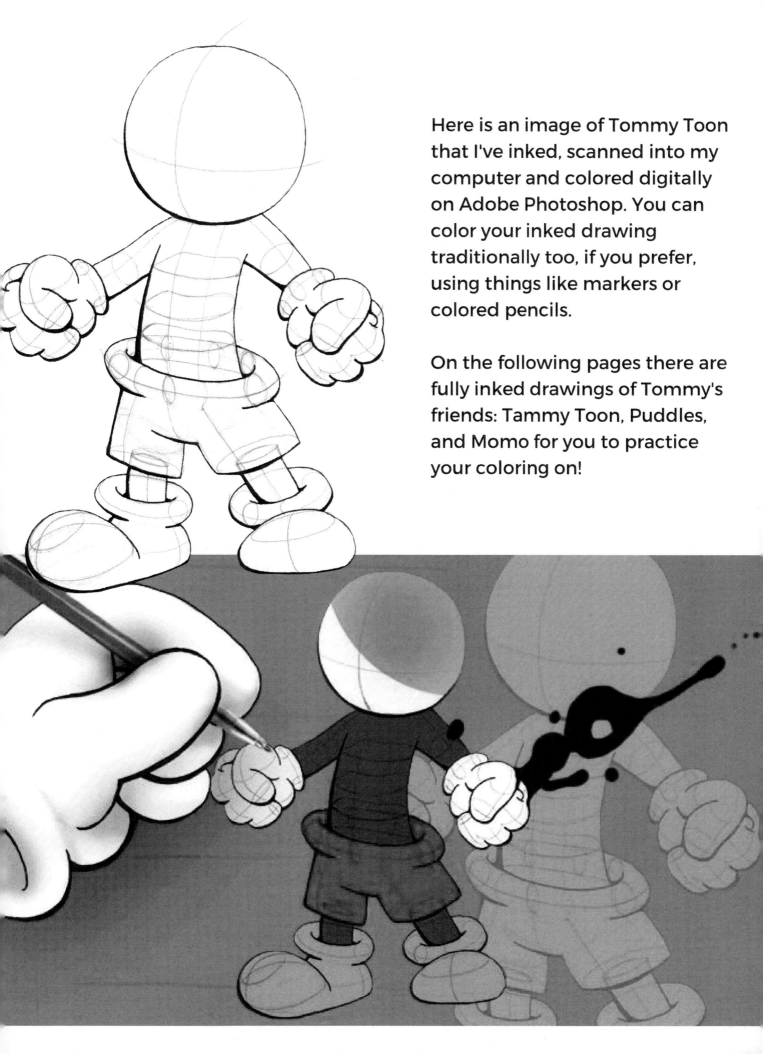

Here is an image of Tommy Toon that I've inked, scanned into my computer and colored digitally on Adobe Photoshop. You can color your inked drawing traditionally too, if you prefer, using things like markers or colored pencils.

On the following pages there are fully inked drawings of Tommy's friends: Tammy Toon, Puddles, and Momo for you to practice your coloring on!

TAMMY TOON

COLOR SHEET

Get FREE Drawing Lessons & More! www.drawcademy.com

MOMO
THE MAGICAL COW

CHAPTER 8

VISUAL ELEMENTS
OF ART

In this chapter you will learn about the 5 visual elements of art and how to apply them to make your drawings better!

THE 5 VISUAL ELEMENTS OF ART

Every drawing ever created is composed of 5 elements. It is important to know these so you can decipher what part of your images you are creating and what needs to be improved upon in the future.

Line- Either straight or curved, this is a mark that spans the distance between two points (start and end). Essentially it is a dot in motion, and the width is determined by the mark-making tool being used (i.e pencil or pen). A line has width, direction. length, and curve. An outline is a type of line, as is cross-hatching, but an outline creates a 2-dimensional shape when it is completed, A shape can be organic or geometric in nature.

Form- The form in an image is the illusion of perceived volume and depth created by employing techniques such as shading and perspective. The tonal scale (also known as the value scale) is the amount of lightness or darkness present in any given colour. The difference in tones next to each other is called contrast and this can be used in the process of giving a shape its form.

Texture- The texture is the description of how something looks or feels in an image. There are two types of textures: visual and tactile. A visual texture is one that is completely flat but gives the illusion of it being raised off of the page and a tactile texture is one that actually rises off the page and can be felt with touch (like a glob of paint). A painting will typically have more tactile textures than a drawing because of how some types of paint dry. Some examples of textures are bumpy, smooth, fuzzy, wet, and rough.

Colour- There are 3 properties to the element of colour: hue, saturation, and value/tone. Hue refers to the wavelength of the light photon when it reaches our eye. It is the name we give colours such as red or blue. Saturation, also known as intensity, is the purity of the colour. The more saturated the colour is the more vibrant it is and the less saturated it is the closer to a dull grey it becomes. Value/ Tone (see #2) is the amount of black or white present in a colour creating brightness or darkness.

Pattern- An underlying structure of form and space that is organized in consistent and regular way to promote rhythm. It can be either man-made or natural.

INK MONSTERS

Visual Element: **LINE & SHAPE**

EX: SPIKEY

Draw this character with different shaped bodies.
make them goopy, spikey, fuzzy, bumpy, and wavy!

INK MONSTERS

Visual Element: **FORM**

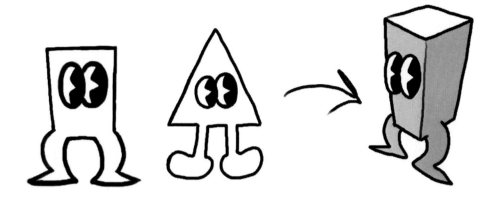

Draw these characters with a 3rd dimension and shading to create a 3/4 view!

 FREE Drawing Lessons & More! → www.drawcademy.com

TOMMY TOON

Visual Element: TEXTURE

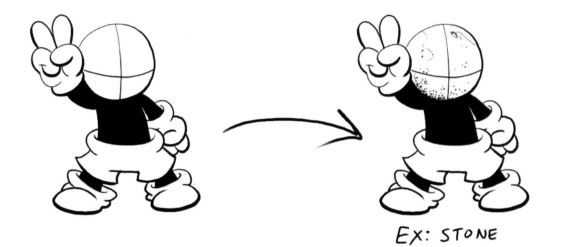

EX: STONE

Make Tommy Toon's head appear as different materials. Try your hand at fur, wood and stone!

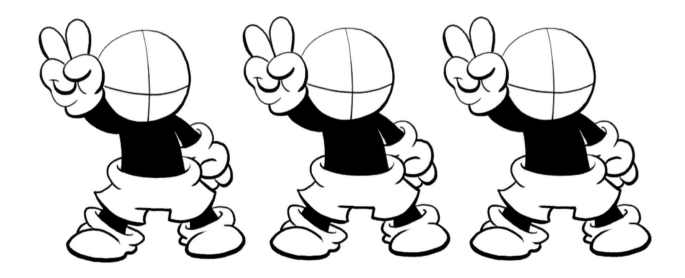

INK MONSTERS

Visual Element: COLOR

Use complementary colors to seperate these monsters from the backgrounds!

Red/Green
Purple/Yellow
Blue/Orange

Use any hue. Use it to color these monsters from most saturated (starting at the left) to least saturated!

 FREE Drawing Lessons & More! www.drawcademy.com

INK MONSTERS

Visual Element: PATTERN

Use these shape characters to arrange your own pattern! If you want, color them to add an extra pattern to the sequence after!

Draw your pattern below:

level up!

CARTOON DRAWING QUIZ

Awesome job! You've made it through the book! Hopefully you've read all of the information inside, Drawn Tommy Toon, and filled out the worksheets. On the next page, there is a skill-testing quiz for you to answer.

Are you ready?!

If you believe you have what it takes, you can take this quiz digitally on the Drawcademy website and try to obtain your own official Drawcademy Certificate of Achievement and a Bonus Gift! It is available to the most ambitious students for completing this quiz with a high score! To get there, follow this link:

www.drawcademy.com/p/cartoon-drawing-for-the-absolute-beginner

Best of Luck, Artists!

THE OFFICIAL DRAWCADEMY
CARTOON DRAWING QUIZ

How many heads tall is Tommy Toon?
A) 2 B) 5 C) 4 D) 3

What is a 2D circle drawn on an angle called?
A) triangle B) oblong C) sphere D) ellipse

Interior contour lines help us understand what?
A) characters B) math C) shape topography D) grids

Tommy Toon's extended hand is approximately the length of his what?
A) legs and arms B) head C) shorts D) all of the above

Tommy Toon's cuffs and waistband are known as what 3D shape?
A) cube B) sphere C) torus D) cylinder

A cube is created with how many squares?
A) 2 B) 4 C) 6

To draw a pencil, what 2 basic 3D shapes are the most useful to know how to draw?
A) cube and cylinder B) cone and cylinder C) sphere and cube

To start a drawing, you should do what?
A) draw hard, dark lines B) lightly sketch it out

Line weights achieve what?
A) color B) form, depth, and shadow C) heaviness

When you're done inking what is the next step?
A) drawing pencil lines B) erasing pencil lines C) guidelines

The front of Tommy Toon's shoes is created with what shape?
A) cube B) sphere C) cone D) pyramid

Tommy Toon's legs are the same length as his what?
A) arms B) cuffs C) fingers D) half of his head

Tommy Toon's head is what 3D shape?
A) cube B) sphere C) cone D) cylinder

Tommy Toon's fingers, legs, arms, and torso most closely resemble what 3D shape?
A) cube B) sphere C) cone D) cylinder

To give your character a whimsical feel, you want to mostly include what element in their design?
A) soft edges B) jagged shapes C) hard edges
D) sharp teeth

ART GLOSSARY

In this section you will find definitions of all of the underlined words in this book as well as a few others that will be useful to you!

Apex- The highest point in the climax of a curve, peak, or vertex.

Balance- The state of equilibrium, not overtly leaning towards one side or the other in terms of a character's posture or the overabundance of elements in one area of an artwork's composition.

Curvilinear- A 2D polygon purely created with curved lines and no hard edges, and therefore only have 1 side, much like a circle.

Dimension (1D/2D/3D)- Dimensions are distances of length, width, and height (depth) that are used in order to locate a single point in space on an object. A 1D object only requires length to find the location, a 2D object requires length and width, and a 3D object requires length, width, and height. Interior contour lines are 1D lines on a shape that help the viewer understand the dimension and form of it.

Guideline- Lightly drawn pencil lines that are created at the very first stages of a drawing to map out the overall form and placement of objects. By the end, these lines are erased because they are purely functional.

Inker- The professional artist who's job it is to apply inks to a picture, most commonly in comic books.

Interior Contour Lines- These are parallel lines that describe the topography of any given shape. They help the viewer understand the dimension and form of any shape imaginable.

Irregular Polygon- A 2D shape created with crossing lines, unlike a regular polygon.

Line Drawings- A drawing created by only using lines to define the edges of objects. in nature this is not how things appear, because outlines do not really exist, so these typically will have a cartoonish feel to them.

Opaqueness- The ability of an object to block the passage of light through itself. For example, glass is more transparent than a curtain. In terms of artistic mediums, watercolor is more transparent than acrylic paint.

Organic Lines- Any combination of curvilinear and rectilinear lines that create objects with a natural feel. A happy medium.

Parallel- Lines that will never cross no matter how far you extend them into the distance. When you are drawing interior contour lines, think about making them as parallel to eachother as possible.

Penciller- The professional artist that creates the original pencil drawing, particularly in a comic book. The penciller will usually pass the finished drawing off to the Inker when they are done.

Perpendicular- Lines that intersect eachother at a right angle.

Perspective Drawings- A drawing that uses vanishing points on a horizon line to accurately and realistically place geometrical objects in the picture plane.

Proportions- The divisions and measurements needed to create a standardized model of a character, creature, or organic form. Proportions must be used in creating a true-to-life rendition of the human form, for example.

Rectilinear- A 2D shape created only with straight lines with hard edges to create rectangular sides in the vertical and horizontal planes. The opposite of curvilinear.

Regular Polygon- A 2D shape that is balanced and has an easily defined name such as a square, rectangle, or octagon. Its sides do not cross each other. They are also known as a simple polygons.

Rigging- An underlying framework, or skeleton, in which more complex objects are drawn on top of in order to maintain proportions.

Transparency- The ability of an object to allow light to pass through it, allowing the viewer to see through to the other side. For example, glass is more transparent than curtains. In artistic mediums, watercolor is more transparent than acrylic paint.

Student Testimonials

If you are still unsure if Drawcademy's video courses are right for you, check out what these students had to say:

"I have never been able to draw, but this course has taught me that by breaking down a drawing into individual shapes, it is possible to put some of my ideas onto paper. Great course I am putting into practice what I have learned."
-Keith

"Great intro course! I learned a lot already with the apprroach used by you. I am considering additional courses based on what I've seen. Your methods are so easy to follow with tangible results for someone at my level."
-Boysie

"Very good introduction to properly drawing a cartoon character! The instructor shows the student how to think of a character not only in 2D shapes, but more importantly in 3D forms which will help the student avoid flat and disproportional looking figures. The over-the-shoulder approach works very well as you can grasp immediately the concepts shared and it also gives you inspiration and confidence to try it yourself since he breaks it down into easy steps. By the end of the course, you'll definitely learn how to make a good looking and properly 'built' drawn character."
-Steve

"I have improved IMMENSELY in the past 30 minutes! WOULD RECOMMEND."
-Wade

THIS HAS BEEN A
DRAWCADEMY
PRODUCTION IN
PARTNERSHIP WITH RED
CAPE FILMS

THANKS FOR READING!

Made in United States
North Haven, CT
16 December 2021

12945258R00054